SHAG'S
Zodiac

SHAG'S

OFFBEAT ADVENTURES IN ASTROLOGY

EVE LEDERMAN

ILLUSTRATIONS BY SHAG

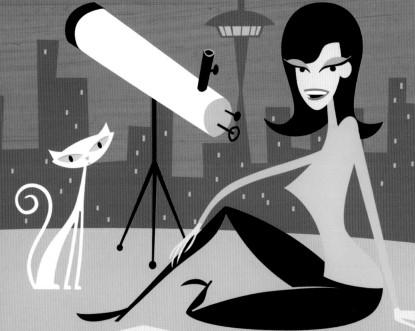

ZODIAC

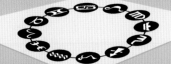

SURREY BOOKS
CHICAGO

What's Your Sign?

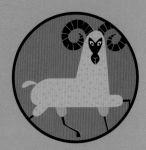

ARIES
page 7

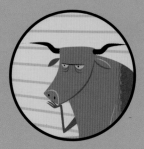

TAURUS
page 13

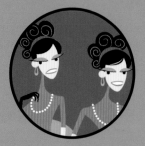

GEMINI
page 19

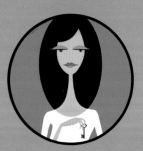

VIRGO
page 37

LIBRA
page 43

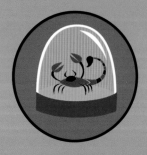

SCORPIO
page 49

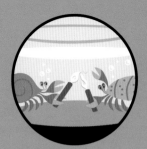

CANCER

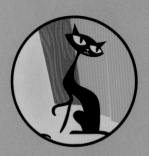

LEO

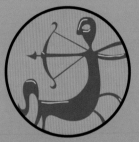

SAGITTARIUS

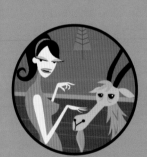

CAPRICORN

PISCES

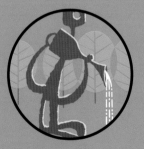

AQUARIUS

This irreverent, inside scoop on astrology dissects the minds of your family and friends to uncover their peculiar and sometimes dysfunctional virtues. It helps you examine their quirks, expose their hang-ups, and then push their buttons in a lovingly wicked way.

We tell it like it is, down and dirty. And if you don't agree with your zodiac description, well, then being argumentative is probably just one of your traits.

ARIES

MARCH 21 – APRIL 19

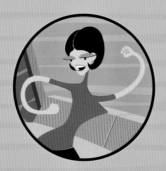

Aries are full of action, always willing to take charge—whether they are supposed to or not! They are the first sign in the zodiac and full of creative ideas. At a young age, you'll find them blowing up the basement with a science project.

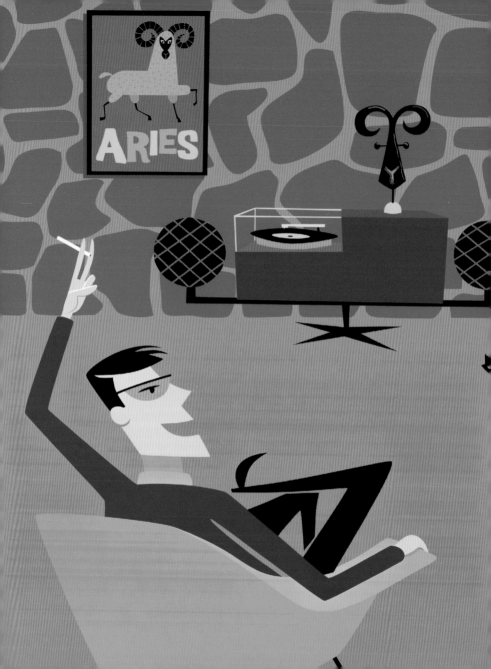

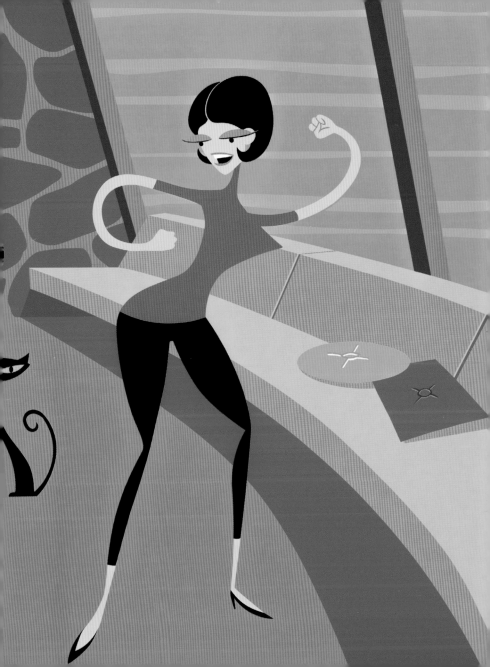

Aries are **pioneers** and inventors. With an inspiring **spirit** that makes them leaders, Aries are always on the **cutting edge**... their baggy pants were slipping south back while the rest of us were struggling into skin tight designer jeans.

Aries **live to compete**, so make sure your first date is full of **challenges**. Turn dinner into a food eating competition. A staring contest. Or clear off the table for a mid-meal **arm wrestle**. Aries love people who can beat them, so go ahead, eat the whole pie. With your hands. In three minutes. Your ram will be so proud.

…ers: athlete, political figure, toreador.

SPONTANEOUS, though sometimes impulsive (they're the ones who buy stuff right next to the cash register), Aries follow their hearts in love and in life. Favo…

11

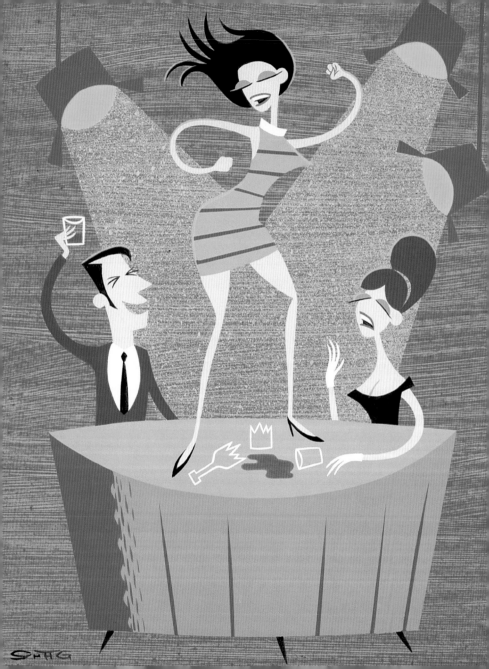

TAURUS

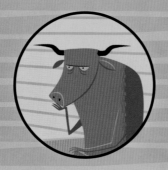

That's a Taurus auctioning off a ball of pocket lint online. If there's **money** to be made, Taurus will **turn a profit**. Favorite jobs: stock broker, real estate developer. Favorite hobbies: rolling **pennies**, carrying that silly metal detector on the beach.

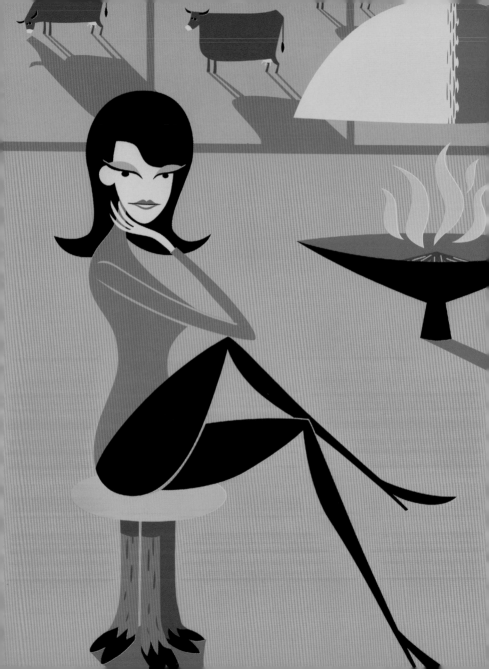

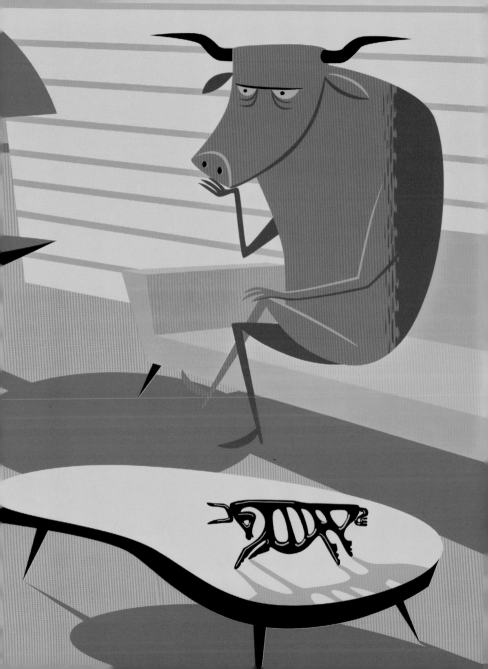

Taureans **like order.** A solid 50-year plan. A list of their lists. Coupons **ordered** and **color coded** by size, date and food group. They also **hate waste.** Taureans save and **scrimp.** They compost. First date, think burger and fries. But not if the fries **cost extra.** And don't be surprised if he purchases your meal from the drive thru because it takes more gas to start the car again than to keep the motor running.

Yes, they are stubborn. Somewhere a Taurus is still trying to prove the world is flat.

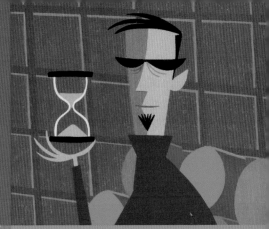

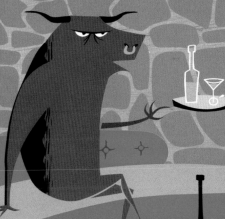

And they are practical with stable, predictable routines.

But underneath that solid bullish exterior is a soft heart and gentle spirit.

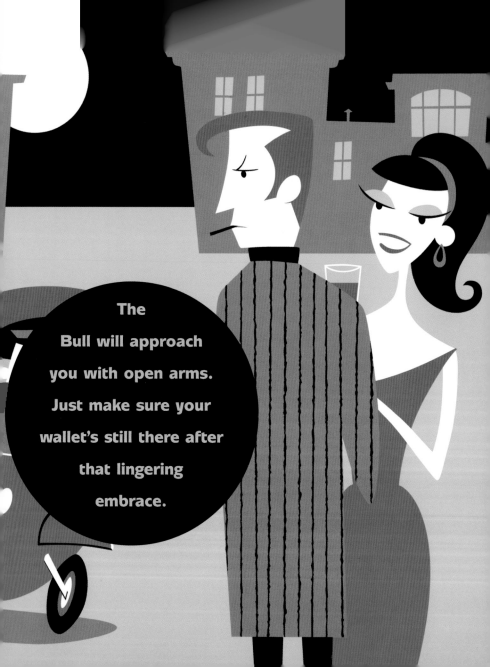

GEMINI

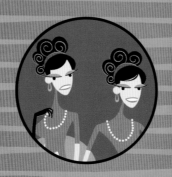

Gemini is a **chameleon** with two personalities reflecting a **dual** nature. They are multidimensional with talents that come in pairs: some are **bilingual** while others excel in many sports.

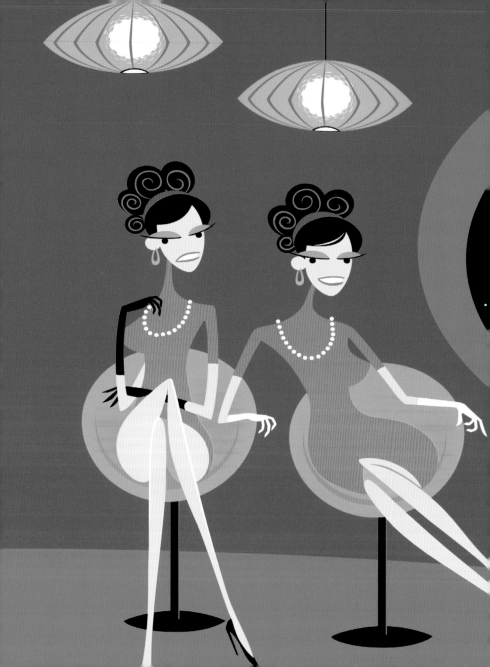

The more elite can drink milk while whistling through their noses. Life is an **adventure** for the **unpredictable** Gemini who may pursue a career as a trucker, harpist, or mortician . . . all in the same year.

Geminis **love to flirt** . . . with you, your grandmother, just about anyone still breathing. With an iron lung. Hooked to an oxygen tank. All the better since they won't impose on Gem's **solo repartee.** No surprise that they also **avoid restriction** and commitment, racking up marriages like speeding tickets.

GEMINIS twist and squirm and climb their way around you with words, kind of a verbal game of twister. They are slick and clever, a thousand car salesmen woven into one. Before you know it, you've been talked into buying a lifetime supply of dehydrated water.

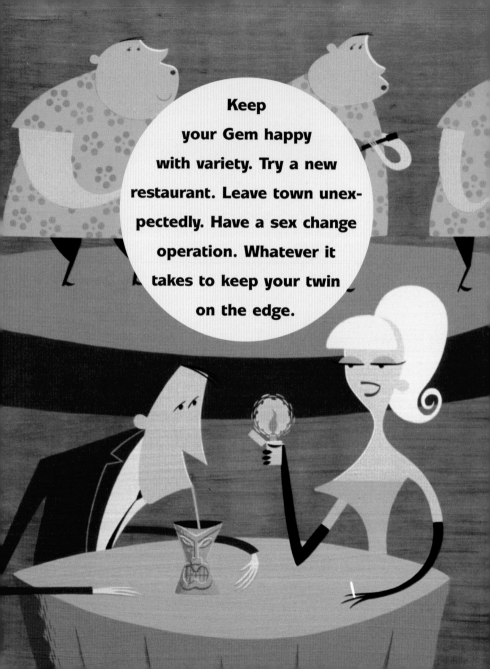

Keep your Gem happy with variety. Try a new restaurant. Leave town unexpectedly. Have a sex change operation. Whatever it takes to keep your twin on the edge.

CANCER

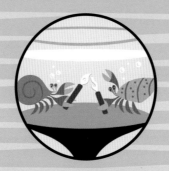

Cancer is a **kind** and self-less soul, the **caretaker** of the world. So loving. So **nurturing**. So irritatingly attentive. Cancer will send you a card on Valentine's Day . . . and Presidents' Day and Groundhog Day.

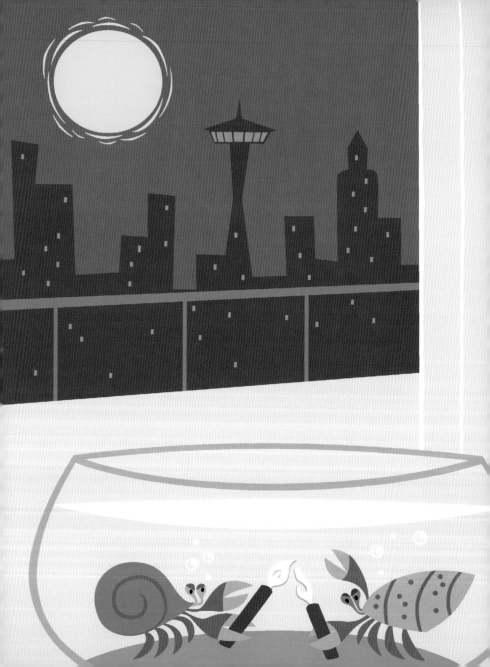

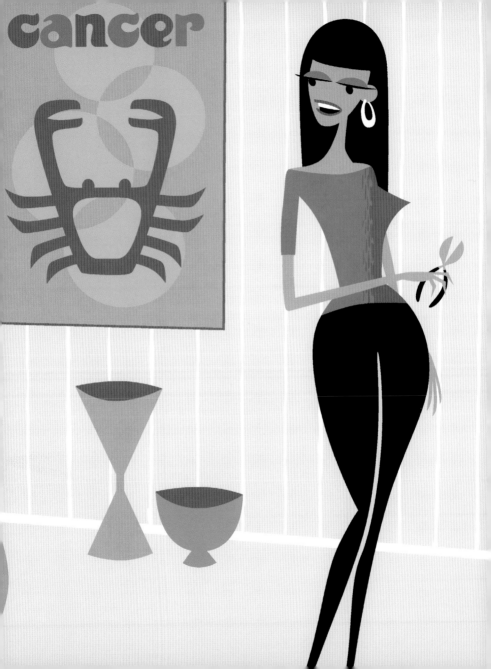

Outnurturing Cancer is the only way to get in one's good graces. Write a thank-you note in return. And deliver it with flowers.

You'll have to **decipher** your covert crab who is **incapable** of **direct** communication. If you notice Cancer wiping a spill with the Business section, he's telling you he got fired. If she hurls a shoe at you, she's not angry; rather, she wants you to buy her that pair she was eyeing at the mall.

Cancers make wonderful nurses and **social workers**. Given their lack of verbal skills, they also make fine morticians.

If you want to attract your crab, don your flannel bathrobe—this guy's a homebody at heart.

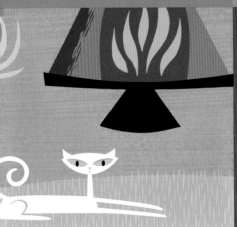

He's a sap for sentimentality and geared toward family and security.

You'll never find him watching televised sports on Sunday because he'd rather be in the basement with his découpage.

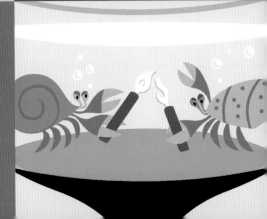

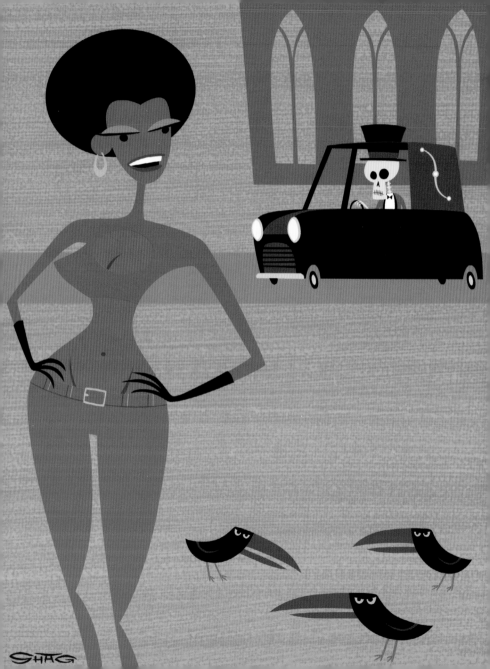

LEO

JULY 23 – AUGUST 22

With their grandiose airs, Leos are born to dazzle. They are the ones wearing the ten heavy gold chains . . . at the office. Enchanting and playful, they need to be stroked like cats to keep them happy.

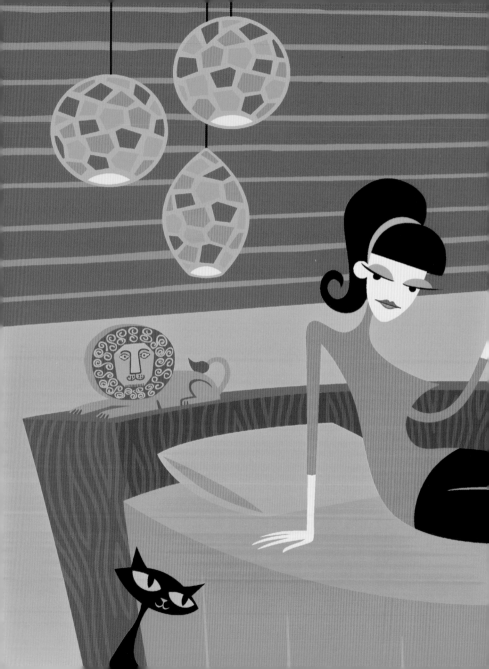

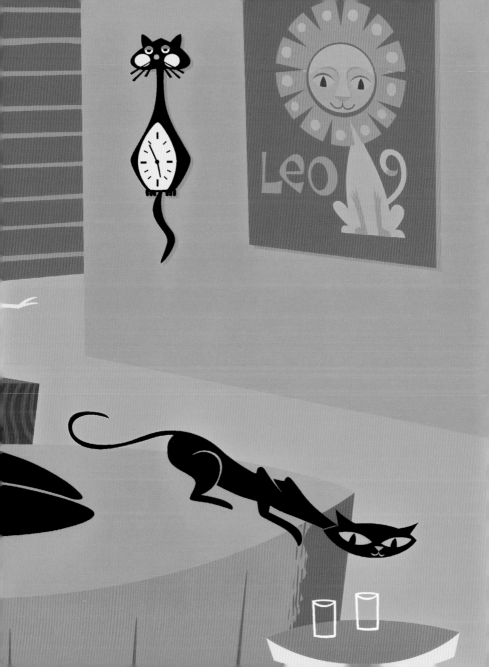

Prideful Leos demand respect and **recognition**, but flattery will get you nowhere . . . unless you are simultaneously **bowing** and applauding. Only then will a Leo consider stepping down off his **throne** so you can shine his shoes.

No need for champagne and slinky clothes to **attract a Leo**. "Tell me about yourself" is the most **seductive** approach in the lion's universe. Compliments work well too. Praise his **good looks** and strong supple body. The way he flosses with such **tenacity** and verve.

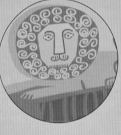
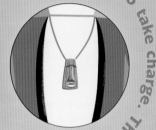

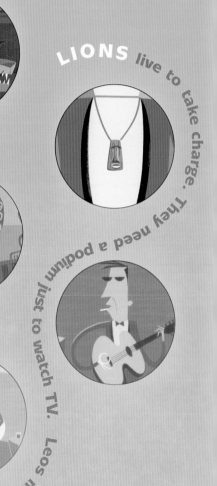

LIONS live to take charge. They need a podium just to watch TV. Leos make great movie directors, CEOs, rock stars and Mafiosos.

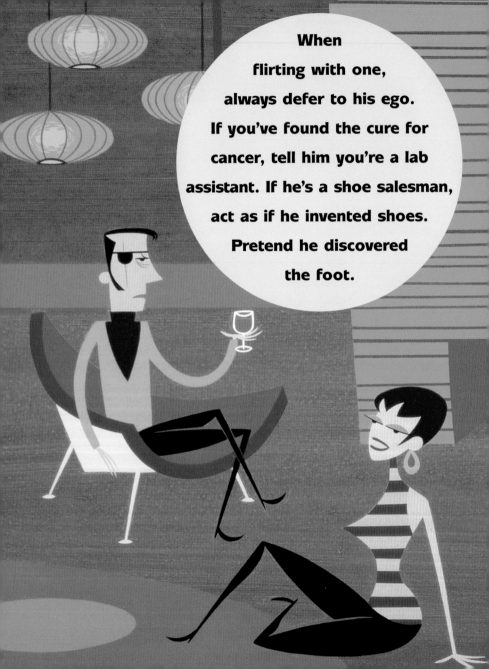

VIRGO

Virgos represent **serenity**. They are the world's problem solvers, **calm** in the face of chaos. With a thirst to **assist others**, you'll often find them **volunteering** and giving to charities. Unfortunately, they don't know when to stop—they would pay your phone bill if it could better the world.

Want to impress the pure Virgo on a date? Treat her to a delectable dinner of shredded soy gluten with boiled cabbage. No need for an exciting Saturday night out on the town. If you want to get your male Virgo in the mood, put on some sitar music and help him reorder the sock drawer. Whisper sweet words like "organization" and your meticulous Virgo will go wild.

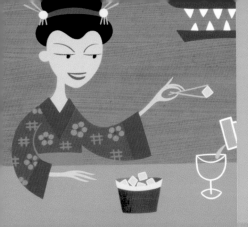

Does your Virgo correct your grammar? Re-sort your recycling? Threaten to control every nuance of your daily life?

Ahh, true love, Virgo style.

Being detail-oriented and precise, Virgos excel as detectives,

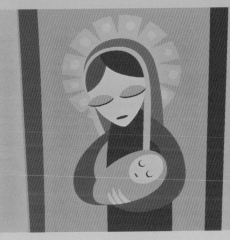

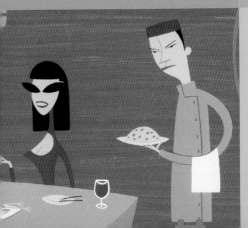

librarians and tax officers. With their unquenchable desire to serve others, they also make fine waiters.

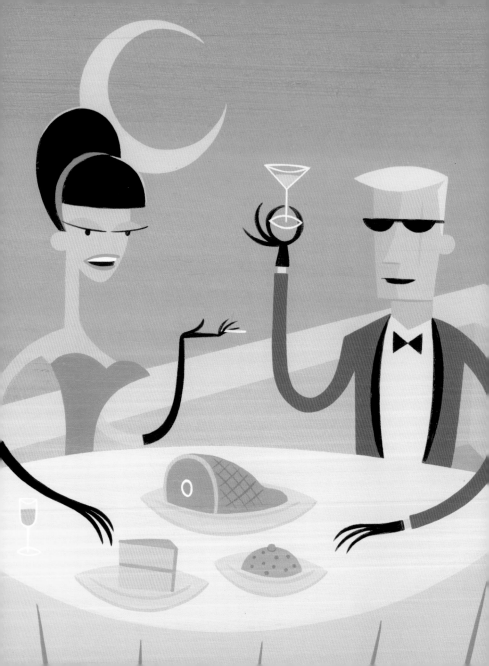

LIBRA

SEPTEMBER 23 – OCTOBER 23

Libras epitomize grace. They are irresistibly charming and refined. "Those extra ten pounds look good on you," a Libra might say. They are sensitive to others and good listeners . . . though they're not actually hearing what you're saying. If a Libra asks your opinion, he's already made up his mind.

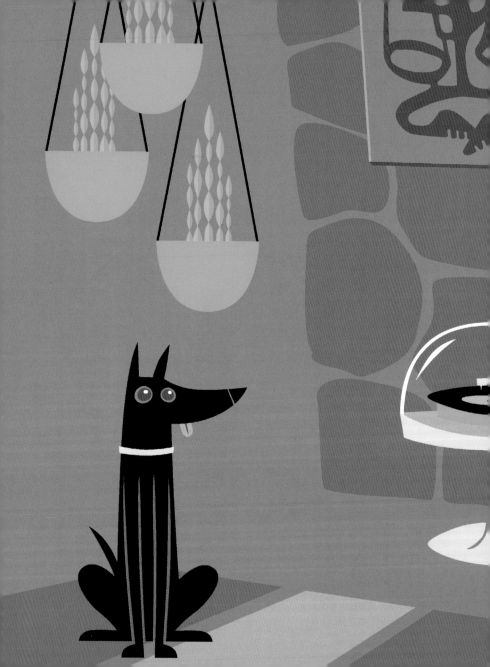

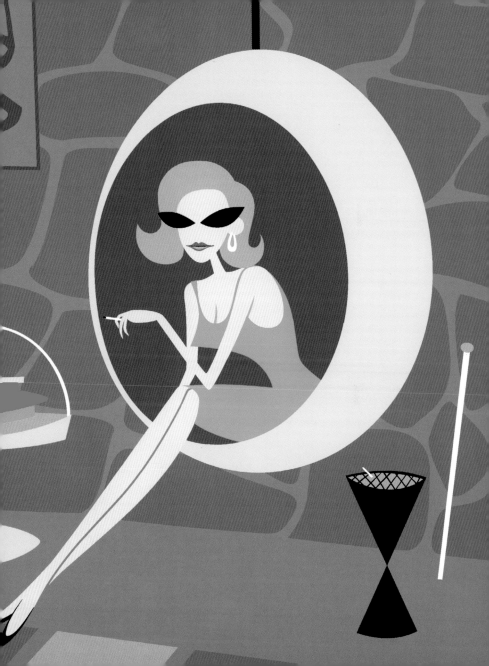

Libras are social creatures who crave **harmonious** relationships. They love partnerships and want to **share** everything with you . . . ideas, **dreams**, hobbies, the **flu**. But when your Libra wants to have that "relationship talk," watch out! Libras love to turn lively discussions into **heated debates** into **arguments**, and you'll find yourself packing your bags or making a proposal without knowing what hit you. If you find yourself in a psychological **headlock**, always take the blame. "You're right, dear. I'm sorry" always works.

LIBRAS weigh all options before making a decision, making graphs, charts, and tables to analyze business options and grocery lists. If they can ever settle on a career, they are guaranteed success as diplomats, referees and tightrope walkers.

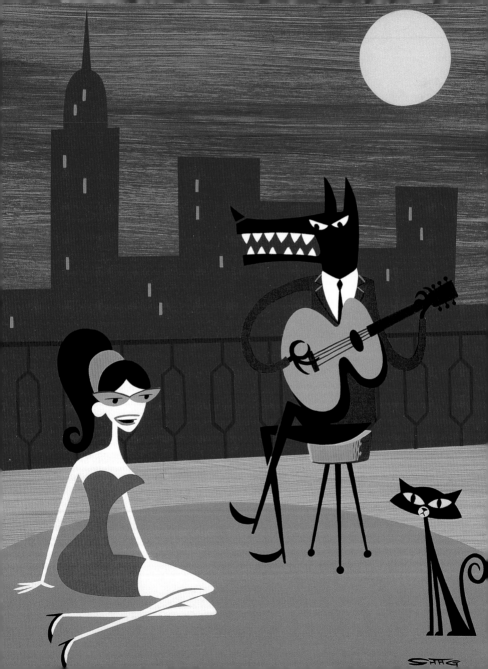

SCORPIO

OCTOBER 24 – NOVEMBER 21

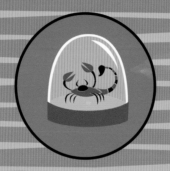

Oh, that Scorpio swagger. Bold. Brash. Magnetic. You evoke awe with your powerful presence. When you enter a room, everyone's hair stands on end, as if they've just been rubbed violently with balloons.

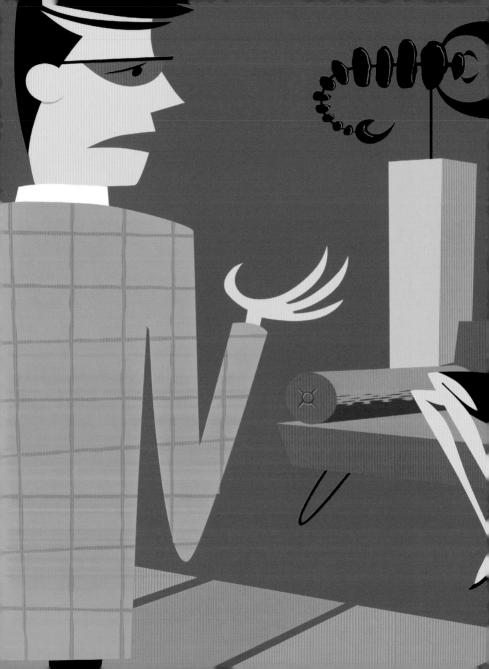

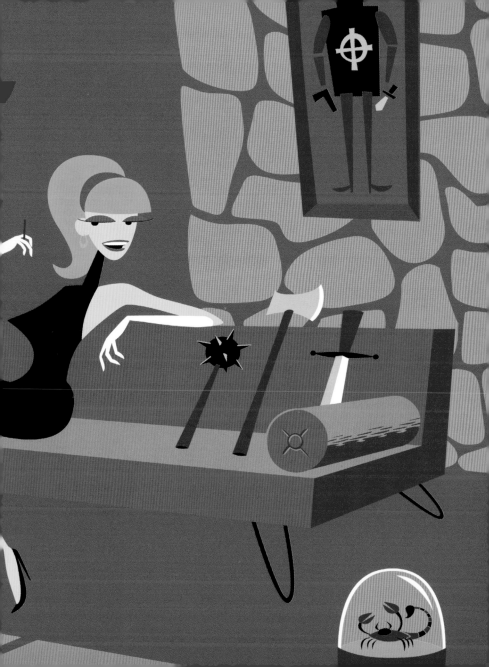

Scorpio's key word is control —of body, mind and soul. You like things neat and orderly so you can keep your eagle eye on everything. If someone takes your pen, you'll track it down and find out how much ink was used. Then return it to your desk and line it up a half inch from the lamp.

Scorpios are full of surprises and mystery. Think leather underwear under those overalls. With their inquisitive minds, Scorpios make good private investigators, surgeons and reporters. The less heady ones make fine exterminators.

Looking for romance
with a Scorpio?
Scorpios live for pas-
sion. Radiate passion.
They invented passion.

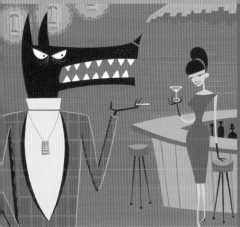

Don't ever tell a
Scorpio, "Not tonight
dear, I have a
headache."

They will ply you
with aspirin, cold
compresses and a
lobotomy if
necessary.

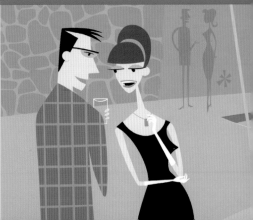

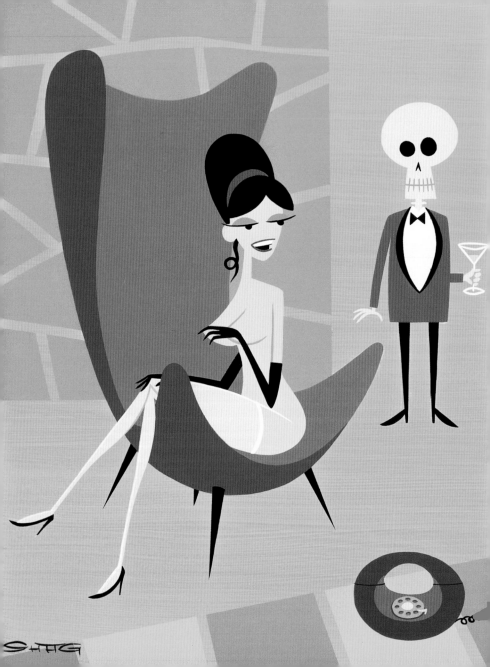

SAGITTARIUS

NOVEMBER 22 – DECEMBER 21

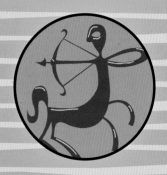

Sagittarians are **amiable** and **enthusiastic** with a spirit for **excitement**. They are inspirational and known for their **optimistic** outlook on life. Cut off one of their legs and they'll thank you for helping them drop twenty pounds.

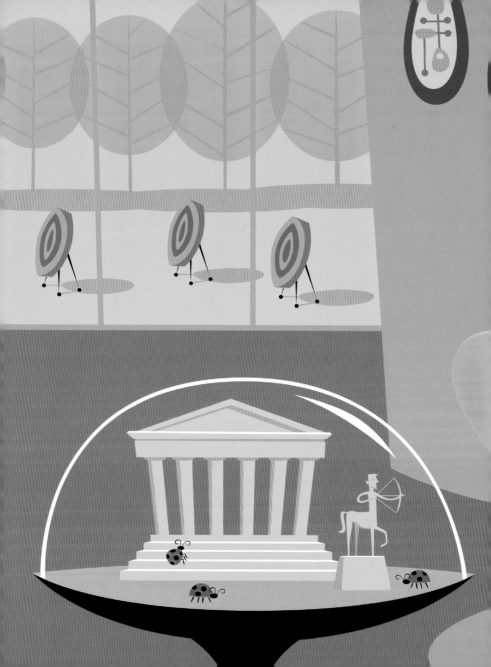

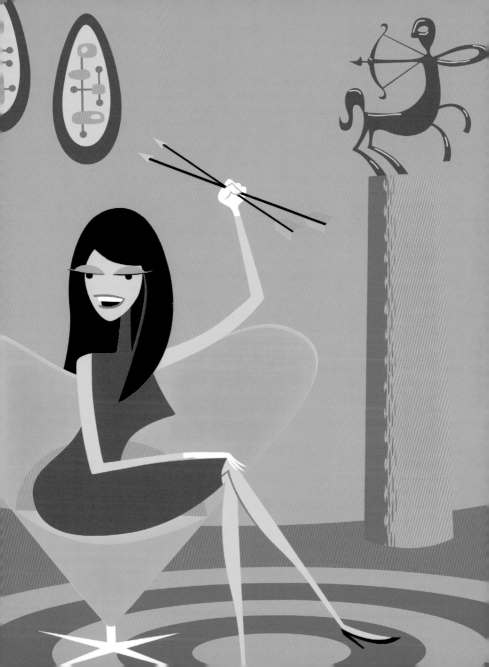

Blunt and outspoken, Sagittarians are the masters of backhanded compliments. "It's refreshing to see someone who doesn't care how he looks," one might say. Or, "I really respect your attempt to try something new with your hair."

Sagittarians need freedom to explore and seek adventure, and they live in the moment. Take your Archer on a spontaneous first date to Paris. Or if you can only afford the local pizza joint, drop her off unexpectedly at a highway exit ten miles from home. After dark. During a snowstorm.

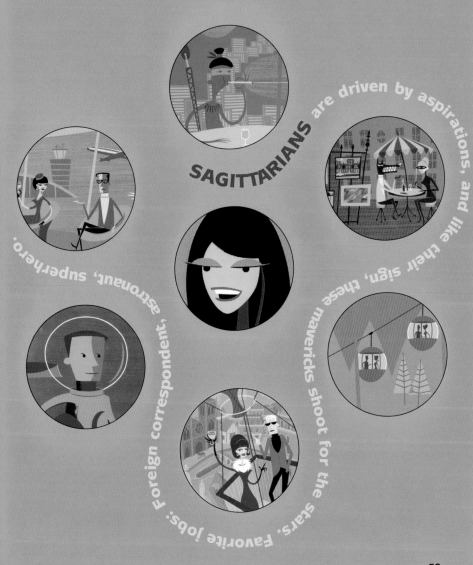

SAGITTARIANS are driven by aspirations, and like their sign, these mavericks shoot for the stars. Favorite jobs: Foreign correspondent, astronaut, superhero.

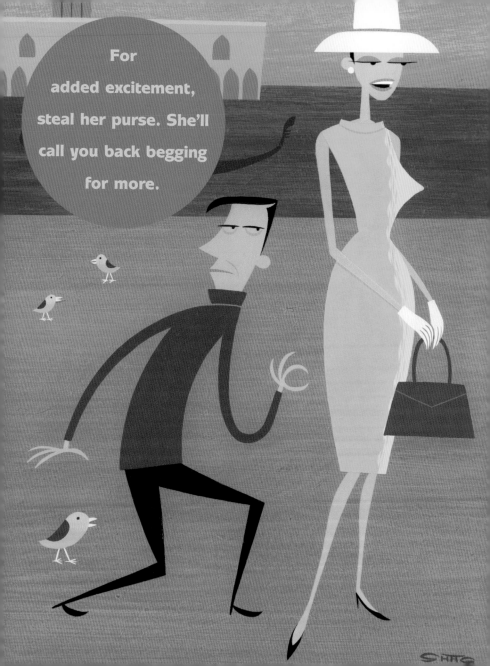

CAPRICORN

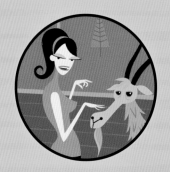

Capricorns are **suave**, stately and **dignified**. With an ability to focus and a **take-charge** attitude, these **ambitious** people are driven from an early age to **succeed** and make **money**. They built their own cribs when they were three. Heck, they probably changed their own diapers.

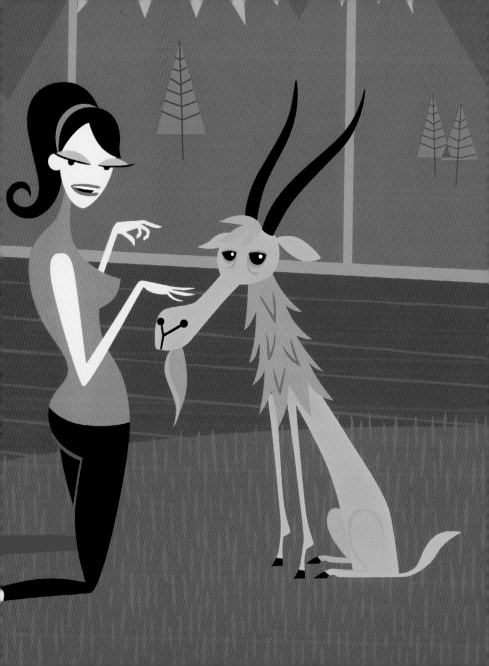

Want to **attract** a Capricorn? Don't bother wooing him with your good looks, just tape a **twenty** to your forehead. To impress him, use the word **"profit"** profusely and watch your **manners**; do not double dip your chip, as Capricorns are highly **refined**. Send him a memo after dinner quantifying your good traits, along with an itemized receipt. But beware— don't expect **fireworks** with this fellow. A Capricorn's idea of a joke is to straighten his tie.

You'll never meet a Capricorn at the office because he owns the office, the company

and probably the entire building. With their drive for achievement and ability to surmount

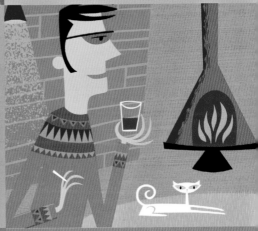

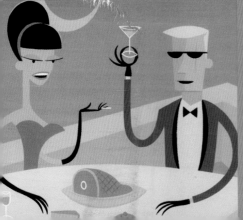

obstacles, sturdy goats can succeed in any endeavor.

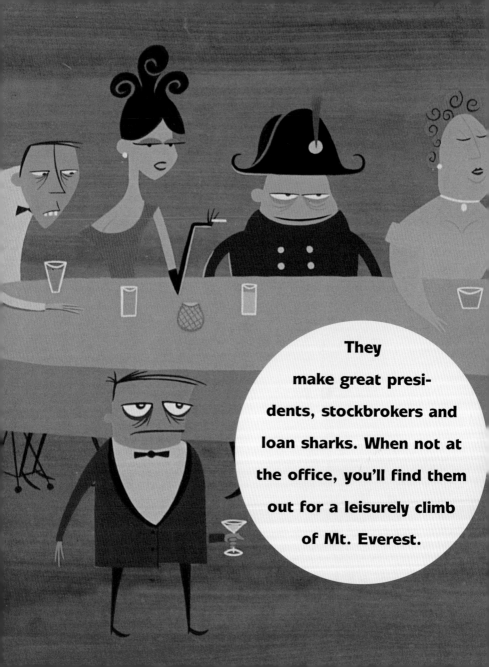

They make great presidents, stockbrokers and loan sharks. When not at the office, you'll find them out for a leisurely climb of Mt. Everest.

AQUARIUS

JANUARY 20 – FEBRUARY 18

Aquarians have a special spark of genius and start life with their own agenda (probably feet first). Brilliant and eccentric with a unique personal style, they can unravel the theory of entropy . . . but find laundry a complete mystery.

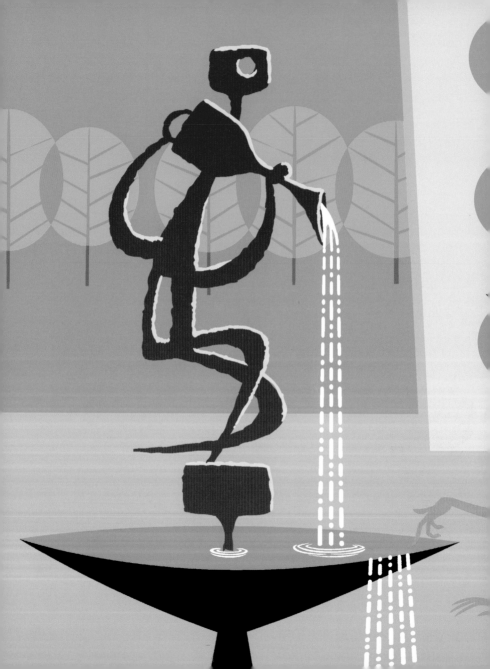

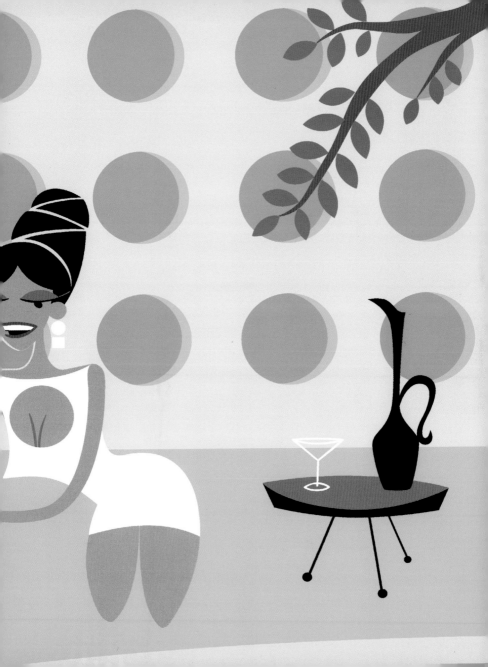

If you want to win over an **Aquarian** on a first date, attend a UFO conference. Go to a **peace** march. Join a knitting circle. Don't show up. Aquarians are as **unconventional** as they come. Anything unexpected will keep them on their toes and begging for more.

If you comment on the nice weather to an **Aquarian**, you've opened up a discussion on ozone depletion and deforestation.

If an **AQUARIAN** gazes dreamily into your eyes over dinner, he might be falling for you, but more likely he's contemplating time travel. Be prepared for every conversation to be cerebral.

Aquarians are the typical mad **professors.** They make great **astrologers,** mathematicians, and **scientists.** Sunday afternoons you'll find them attempting to telepathically bend a spoon or wandering **aimlessly** around the neighborhood . . . trying to remember where they live.

PISCES

FEBRUARY 19 – MARCH 20

Pisces go with the **flow** without making **waves**. Kind and **compassionate**, you are always caring for others. You let friends cry on your **shoulder**. Help a child cross the street. You **talk to plants**.

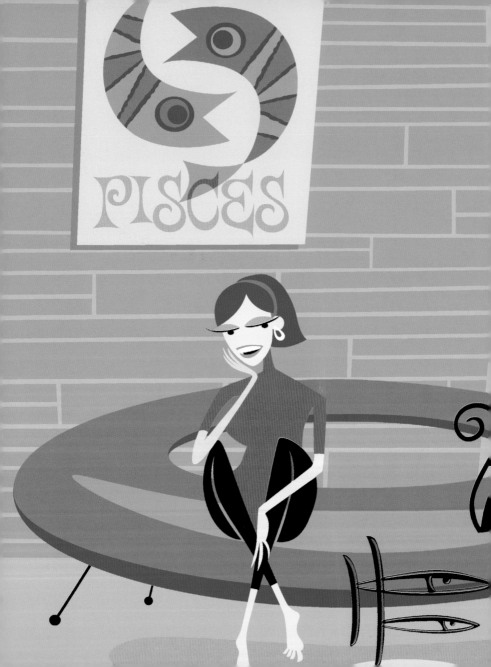

Is that a Pisces out for a jog or is he chasing moonbeams? Pisces are dreamers, creative thinkers, in tune with the infinite mysteries of the world. You might be the next Van Gogh, if you could only remember where you put the paint.

When it comes to romance one thing's certain—you'll never be on time. But don't worry, your mate will understand why you're late for the wedding. Musing on quantum physics, it's easy to lose track of time. When you finally get there, though, it won't matter because with your partner (hopefully an Aquarius or Scorpio) you're all about the vibe.

With such a sensitive soul it's likely that you'll find your life's work helping others

with a career in medicine, law or plumbing (since you are so drawn to water).

Candles, crystals and magic satisfy your mystical nature. So do Chia Pets.

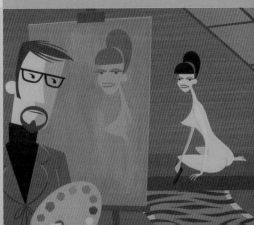

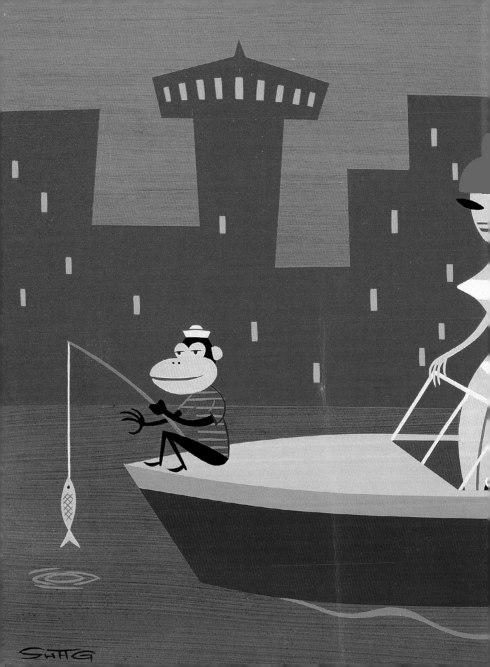

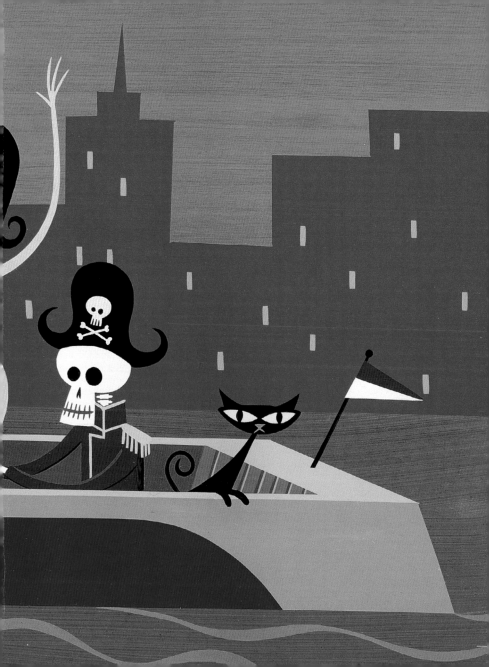

SHAG'S ZODIAC: OFFBEAT ADVENTURES IN ASTROLOGY
is published by Surrey Books, 230 E. Ohio St., Suite 120,
Chicago, IL 60611.

Illustrations by Shag
Text by Eve Lederman
Designed and typeset by Joan Sommers Design, Chicago
Printed and bound in China by C&C Offset Printing Co., Ltd.

5 4 3 2 1

Library of Congress Cataloging-in-Publication Data

Lederman, Eve
 Shag's zodiac : offbeat adventures in astrology / Eve Lederman ;
illustrations by Shag.
 p. cm.
 ISBN 1-57284-067-6
 1. Astrology. I. Title.
BF1708.1.L395 2004
 133.5—dc22 2004010791

Distributed to the trade by Publishers Group West.

www.surreybooks.com
800.326.4430